THE FILMMAKER SAYS

Also available in the Words of Wisdom series:

The Architect Says
Laura S. Dushkes
978-1-61689-093-3

The Designer Says
Sara Bader
978-1-61689-134-3

The Chef Says
Nach Waxman & Matt Sartwell
978-1-61689-249-4

Published by
Princeton Architectural Press
37 East Seventh Street
New York, New York 10003
Visit our website at www.papress.com.

Editor: Megan Carey
Designer: Elana Schlenker
Series designer: Paul Wagner

Special thanks to: Meredith Baber, Sara Bader, Nicola Bednarek Brower,
Janet Behning, Carina Cha, Andrea Chlad, Benjamin English, Russell Fernandez,
Will Foster, Jan Haux, Emily Johnston-O'Neill, Diane Levinson, Jennifer Lippert,
Katharine Myers, Lauren Palmer, Margaret Rogalski, Jay Sacher, Dan Simon,
Sara Stemen, Andrew Stepanian, and Joseph Weston of Princeton Architectural Press
—Kevin C. Lippert, publisher

Library of Congress Cataloging-in-Publication Data
The filmmaker says : quotes, quips, and words of wisdom / compiled and edited by Jamie
Thompson Stern. — First edition.
159 pages ; 19 cm. — (Words of wisdom)
ISBN 978-1-61689-220-3 (hardcover : alk. paper)
1. Motion pictures—Quotations, maxims, etc. I. Thompson Stern, Jamie,
1961– editor of compilation.
PN1994.9.F55 2013
791.43'75—dc23
 2013014193

the FILM-MAKER says

Quotes, Quips, and Words of Wisdom

compiled and edited by Jamie Thompson Stern

Princeton Architectural Press, New York

For me, the most exciting part about the movie business is watching dreams become realities. Whether it's the words on a page, the sketch of a set design, or the storyboard of an action scene, seeing those inchoate thoughts coming magically to life is always magnificent. That process is what the filmmakers in this volume are so passionate about. They want to create, to innovate…and to entertain, delight, horrify, or perplex.

Filmmakers love to talk about making movies almost as much as they love (or, in some cases, claim to hate) making them. The voices in *The Filmmaker Says* hold forth on such topics as *auteur* theory, the importance of audience, the creative process, the value of a good story, and the business of show. For all the many movies that have ever been made, there are just as many fervent opinions on what really matters about them. You will see in these pages that filmmakers aren't a particularly humble or retiring bunch. Jean-Luc Godard announces that "cinema is truth" just as vigorously as Brian De Palma proclaims that "film lies." The goal of this compendium is to create dialogues—some direct, and some more subtle—between these points of view.

Directors, screenwriters, producers, cinematographers, studio heads, actors, and critics all get to have their say here. The challenge of choosing what quotations to include was pleasurably complicated by the fact that there are so many witty, garrulous geniuses (Quentin Tarantino, I'm looking at you) whose words have been carefully archived in printed and recorded interviews. Believe me, there's no shortage of material. There is much brilliant commentary out there that *didn't* find its way into these

pages, and I urge you to continue the search. You'll probably also be inspired, as I was, to watch—or rewatch—a lot of old movies.

While compiling this volume, I was struck by the parallels between the process of creating and editing a book and the process of making a film. Editing—on paper or in the movies— is a method of manipulating reality by choosing discrete bits of information, then juxtaposing and recombining them to create a *new* reality. By editing the sequence of the quotes herein as carefully as a sequence of shots in a film, I hope to tie together these disparate thoughts about cinema in a style that relates to film itself.

The seminal French film theorist André Bazin once said that *montage* (editing) enables cinema to have at its disposal "a whole arsenal of means whereby to impose its interpretation of an event on the spectator." In editing this "event" in such a way as to show lively conversations among filmmakers from different eras and with wildly varied sensibilities, I certainly want to draw connections, but I encourage you to feel inspired to formulate your own views on what matters about the movies. After all, as novelist and screenwriter William Goldman famously said, "Nobody knows anything."

Jamie Thompson Stern

No saint, no pope,
no general, no sultan
has ever had the power
that a filmmaker has:
**the power to talk
to hundreds of millions
of people for two
hours in the dark.**

Frank Capra (1897–1991)

PICK UP A CAMERA. SHOOT
SOMETHING. NO MATTER
HOW SMALL, NO MATTER HOW
CHEESY, NO MATTER WHETHER
YOUR FRIENDS AND YOUR
SISTER STAR IN IT. PUT YOUR
NAME ON IT AS DIRECTOR.
NOW YOU'RE A DIRECTOR.
EVERYTHING AFTER THAT,
YOU'RE JUST NEGOTIATING
YOUR BUDGET AND YOUR FEE.

James Cameron (1954–)

IN THE FUTURE, EVERYBODY IS GOING TO BE A DIRECTOR. **SOMEBODY'S GOT TO LIVE A REAL LIFE** SO WE HAVE SOMETHING TO MAKE A MOVIE ABOUT.

Cameron Crowe (1957–)

Get on the floor,
start working.
Get any job you can,
just to get in the
door. Once you get
in the door, if you're
good, you'll move
up so fast, you won't
know what hit you.

Jerry Bruckheimer (1945–)

THEY DIDN'T OPEN THE DOOR. I HAD TO CUT A HOLE IN THE WINDOW TO GET IN. YOU CLOSE THE DOOR ON ME AND TELL ME I CAN'T, I'M GONNA FIND A WAY TO GET IN.

Tyler Perry (1969–)

The first thing you do when you take a piece of paper is always put the date on it, the month, the day, and where it is. Because every idea that you put on paper is useful to you. By putting the date on it as a habit, when you look for what you wrote down in your notes, you will be desperate to know that it happened in April in 1972 and it was in Paris and already it begins to be useful. **One of the most important tools that a filmmaker has are his/her notes.**

Francis Ford Coppola (1939–)

I write down the
idea in my notebook,
and then I put a little
letter in the corner
of the page in a circle.
S for story, N for novel,
M for movie, A for art,
P for performance, B for
business. This makes
me sound totally rigid.
I am also lots of fun!
Totally wild! Party!

Miranda July (1974-)

I DIDN'T GO TO FILM SCHOOL, SO I'M STILL LEARNING IN PUBLIC.

Jonathan Demme (1944–)

Learning to make films is very easy. Learning what to make films about is very hard.

George Lucas (1944–)

THE LACK OF FILM
CULTURE IS ONE OF THE
THINGS THAT REALLY
UPSETS ME. THERE'S
THIS COMPLETE LACK OF
INTEREST IN ANYTHING
THAT WAS MADE LONGER
THAN TEN YEARS AGO....
IT'S LIKE IGNORING
BURIED TREASURE, BUT
IT'S NOT EVEN BURIED.
IT'S RIGHT THERE.

Peter Bogdanovich (1939–)

I think you can study too much. I've seen that happen. Young people get immersed in the work of other directors and end up imitating them rather than finding their own identity. It's important to see the work of as many directors as possible, but you must not become self-conscious. You have to accept that your first attempts are going to be quite rough compared to the finished works of great masters.

James Ivory (1928–)

My first few films were harrowing experiences, because you're terrified the whole time that you're going to fuck it up. You don't know what you're doing.

David O. Russell (1958–)

I think your first
film is always your best.
Always. It may not be
your most successful or
technically accomplished,
but you never, ever get
close to that feeling
of not knowing what you're
doing again. And **that
feeling of not knowing
what you're doing is
an amazing place to be.**

Danny Boyle (1956–)

I WAS AWARE THAT
I DIDN'T KNOW ANYTHING
ABOUT MAKING FILMS,
BUT I BELIEVED
I COULDN'T MAKE THEM
ANY WORSE THAN
THE MAJORITY OF
FILMS I WAS SEEING.
**BAD FILMS GAVE ME
THE COURAGE TO
TRY MAKING A MOVIE.**

Stanley Kubrick (1928–99)

I didn't know what you couldn't do. I didn't deliberately set out to invent anything. It just seemed to me, "Why not?"… **That was the gift I brought to *Kane*… ignorance.**

Orson Welles (1915–85)

I never really got interested
in film per se, until one afternoon
when I saw *Citizen Kane*....It
was a revelation to me, as it was
to a lot of people. **All of a sudden
here was this massive, complex,
involving story that left the screen
with you.** It didn't stay on the screen
and lay back there like certain
kinds of food that you eat and then
five minutes later you're hungry
again. It really stayed with me and
I saw it again and again, five or
six times. It's kind of a quarry
for filmmakers, like James Joyce's
Ulysses is a quarry for writers.

William Friedkin (1935–)

Sometimes when you're heavy into the shooting or editing of a picture, you get to the point where you don't know if you could ever do it again. Then **suddenly you get excited by seeing somebody else's work.**

Martin Scorsese (1942–)

I'M THE BEST PLAGIARIST IN THE WORLD. I STEAL FROM THE BEST. I LIKE TO CALL IT HOMAGE.

Tony Scott (1944–2012)

Devour old films, new films, music, books, paintings, photographs, poems, dreams, random conversations, architecture, bridges, street signs, trees, clouds, bodies of water, light and shadows. Select only things to steal from that speak directly to your soul. If you do this, your work (and theft) will be authentic. **Authenticity is invaluable; originality is nonexistent.**

Jim Jarmusch (1953–)

If you make movies about movies and about characters instead of people, **the echoes get thinner and thinner** until they're reduced to mechanical sounds.

John Huston (1906–87)

THE WORLD HAS ALWAYS BEEN
FULL OF SHEEP. YOU WANT TO
BE A SHEEP, OKAY, THIS IS
A DEMOCRACY. BUT **IF YOU WANT
TO FIND YOUR OWN WAY, THIS
IS THE TIME TO DO IT.** IT'S
NOT HARDER TO BE YOURSELF,
IT'S JUST MORE OBVIOUS
THAT IT'S HARD. REALLY HARD.
IT'S ALWAYS BEEN HARD.
IT WAS HARD FOR KEATS.

Jane Campion (1954–)

For the working director, there is no conscious form from film to film. We all know what our ambitions are, but in a very healthy way **we are all unconscious of "signature."**

Michael Mann (1943–)

PEOPLE ASK YOU
ABOUT YOUR SIGNATURE
ON THE MOVIE, OR
WHATEVER. NOBODY
WANTED TO SIGN THE
DAMN MOVIE. YOU
KNOW WHAT I MEAN?
WE'RE JUST TRYING
TO DO JUSTICE TO THE
STORY. WE'RE NOT
TRYING TO PEE ON IT.

Ethan Coen (1957–)

Success can be a nightmare. When you are identified always with a certain title, with a certain movie, especially with a certain sequence in that movie, it becomes a kind of a little nightmare.

Bernardo Bertolucci (1940–)

IF I MADE *CINDERELLA* INTO A MOVIE, EVERYONE WOULD LOOK FOR A CORPSE.

Alfred Hitchcock (1899–1980)

In France I'm an auteur, in England I'm a filmmaker, in Germany I make horror films, and in the United States I'm a bum.

John Carpenter (1948–)

I think of horror films as art, as films of confrontation. Films that make you confront aspects of your own life that are difficult to face. Just because you're making a horror film doesn't mean you can't make an artful film.

David Cronenberg (1943–)

Life is a tragedy when seen in close-up, but a comedy in long-shot.

Charlie Chaplin (1889–1977)

Tragedy is if I cut my finger. Comedy is if you walk into an open sewer and die.

Mel Brooks (1926–)

Eleven Rules for Box Office Appeal:

1. A pretty girl is better than an ugly one.

2. A leg is better than an arm.

3. A bedroom is better than a living room.

4. An arrival is better than a departure.

5. A birth is better than a death.

6. A chase is better than a chat.

7. A dog is better than a landscape.

8. A kitten is better than a dog.

9. A baby is better than a kitten.

10. A kiss is better than a baby.

11. A pratfall is better than anything.

Preston Sturges (1898–1959)

THERE ARE NO RULES IN FILMMAKING, ONLY SINS. AND **THE CARDINAL SIN IS DULLNESS.**

Frank Capra (1897–1991)

Photography is truth.
The cinema is truth twenty-four times per second.

Jean-Luc Godard* (1930–)

*From *Le Petit Soldat* (1960)

FILM LIES TWENTY- FOUR TIMES A SECOND.

Brian De Palma (1940–)

Films aren't real; they're completely constructed. All forms of film language are a choice, and none of it is the truth.

Todd Haynes (1961–)

As a documentarian, **I happily place my faith in reality.** It is my caretaker, the provider of subjects, themes, experiences— all endowed with the power of truth and the romance of discovery.

Albert Maysles (1926–)

If you ask me what directing is, the first answer that comes into my head is: I don't know.

Michelangelo Antonioni (1912–2007)

All film directors, whether famous or obscure, regard themselves as misunderstood or underrated. Because of that, they all lie. They're obliged to overstate their own importance.

François Truffaut (1932–84)

The key word in art—
it's an ugly word, but it's
a necessary word—is *power*,
your own power. Power to
say, "I'm going to bend you
to my will." However you
disguise it, you're gripping
someone's throat. You're
saying, "My dear, this is
the way it's going to be."

Elia Kazan (1909–2003)

I PROBABLY AM A LAZY ARTIST AND PROBABLY DON'T CONTROL THINGS AS MUCH AS SOME PEOPLE WOULD LIKE— BUT THAT'S MY BUSINESS. AND IF MY STYLE IS TOO LOOSE OR IMPROVISED FOR SOME PEOPLE'S TASTE, THAT'S THEIR PROBLEM—TOTALLY.

Robert Altman (1925–2006)

I TEND TO PUT DOWN THE AUTEUR THEORY BECAUSE A LOT OF PEOPLE EMBRACED IT AS A ONE-MAN/ONE-CONCEPT KIND OF THING, AND **MAKING A MOVIE IS AN ENSEMBLE.**

Clint Eastwood (1930–)

THE BEST FILMS ARE BEST BECAUSE OF NOBODY BUT THE DIRECTOR.

Roman Polanski (1933–)

If you have a strong vision, then you're able to **throw it away for a better one.**

Julie Taymor (1952–)

I don't get attached to anything. I'm like a good antique dealer. **I'm prepared to sell my most valuable table.**

Ridley Scott (1937–)

I LOVE MAKING MOVIES.
IF I WASN'T PAID TO DO IT,
I WOULD PAY TO DO IT.

David Lean (1908–91)

I DISLIKE DIRECTING.
I HATE THE CONSTANT
DEALING WITH VOLATILE
PERSONALITIES.
DIRECTING IS EMOTIONAL
FRUSTRATION, ANGER,
AND TREMENDOUSLY
HARD WORK—SEVEN DAYS
A WEEK, TWELVE TO
SIXTEEN HOURS A DAY.

George Lucas (1944–)

I keep the environment pretty relaxed—relaxed but focused.
I work with the same people all the time. There's a form of band humor that develops: inside jokes and references that only a core group of people understand. It's fun. Some people believe tension is a good creative tool, that you get more out of people if you make them feel insecure. I'm not one of those people, and I don't want to be around that when I go to work.

Steven Soderbergh (1963–)

The fact is that nothing good ever came out of a happy set. You can't stay sharp without friction— that's just physics.

David Fincher (1962–)

I'm used to people not expecting much from me. But then as soon as I start working, that drops away. I don't yell. I'm petite. I don't turn into a tyrant. **Being underestimated is, in a way, a kind of advantage**, because people are usually pleasantly surprised by the result.

Sofia Coppola (1971–)

I DON'T *GET* ULCERS. I CAUSE THEM.

Otto Preminger (1905–86)

The director must be a policeman, a midwife, a psychoanalyst, a sycophant, and **a bastard.**

Billy Wilder (1906–2002)

ULTIMATELY BEING A GOOD DIRECTOR IS A UNIQUE COMBINATION OF MALE AND FEMALE QUALITIES: YOU ARE A FOUR-STAR GENERAL, AN INSPIRATIONAL LEADER AND STRATEGIST, AS WELL AS THE MOST NURTURING MOTHER IN THE WORLD.

Martha Coolidge (1946–)

I BELIEVE WHAT I SAID IS, "ACTORS SHOULD BE *TREATED* LIKE CATTLE." OF COURSE I WAS JOKING, BUT IT SEEMS I WAS TAKEN SERIOUSLY. IF I HAD BEEN SPEAKING SERIOUSLY, I WOULD HAVE SAID, **"ACTORS ARE CHILDREN."**

Alfred Hitchcock (1899–1980)

Actors are the best
and the worst of people.
They're like kids.
**When they're good,
they're very, very good.
When they're bad,
they're very, very naughty.**
The best actors,
I think, have a childlike
quality…an ability
to lose themselves.
There's still some silliness.

Kenneth Branagh (1960–)

The difference between being a director and being an actor is the difference between being the carpenter banging the nails into the wood and being the piece of wood the nails are being banged into.

Sean Penn (1960–)

The difference between directing yourself and being directed, if you'll excuse the analogy, is the difference between masturbation and making love.

Warren Beatty (1937–)

TO BE CANDID, IT'S GOTTEN OUT OF CONTROL. BECAUSE EVERYBODY IS A DIRECTOR, EVERYBODY IS A PRODUCER, EVERYBODY KNOWS EVERYTHING.

Peter Bogdanovich (1939–)

NOBODY KNOWS ANYTHING.

William Goldman (1931–)

IT WOULD BE UNTHINKABLE FOR A WRITER TO TELL A DIRECTOR HOW TO DIRECT OR A PRODUCER HOW TO PRODUCE OR AN ACTOR HOW TO ACT OR A CINEMATOGRAPHER HOW TO LIGHT A SCENE. BUT **IT IS NOT AT ALL UNTHINKABLE FOR ANYONE TO TELL A WRITER HOW TO WRITE.** IT COMES WITH THE TERRITORY.

Ernest Lehman (1915–2005)

They seem to think that once it's printed on paper it becomes gospel. But that isn't so, at least not in my way of thinking.

Howard Hawks (1896–1977)

Give me a good script, and I'll be a hundred times better as a director.

George Cukor (1899–1983)

WELL, THERE'S NO SUCH THING AS A GOOD SCRIPT, REALLY.

John Ford (1894–1973)

THE MOST IMPORTANT
THING ON ANY FILM IS
THAT SCRIPT. YOU'VE GOT
TO HAVE IT, BECAUSE
**IF IT'S NOT ON THE PAGE,
IT'S NOT GOING TO GET OUT
THERE ON THE SCREEN.**
SO THAT'S NUMBER ONE.

Robert Wise (1914–2005)

My scripts are in visual form.... I don't think it's a literary medium anyway, so why waste work?

Satyajit Ray (1921–92)

The images alone
are insufficient.
They are very
important, but they
are only images.
The essential thing
is how long each
image lasts, what
follows each image.
All of the eloquence
of film is created
in the editing room.

Orson Welles (1915–85)

You could not take the camera and just show a nude woman being stabbed to death. It had to be done impressionistically. **So it was done with little pieces of film: the head, the feet, a hand, parts of the torso…the shower itself.** I think in that scene there were seventy-eight pieces of film in about forty-five seconds.

Alfred Hitchcock (1899–1980)

My movie is born first in my head, dies on paper, is resuscitated by the living persons and real objects I use, which are killed on film but, placed in a certain order and projected onto a screen, come to life again like flowers in water.

Robert Bresson (1901–99)

IT'S ALL ABOUT MAKING SURE THE FILM BOUNCES OFF THAT SHEET AND COMES TO LIFE IN THE MIND OF THE AUDIENCE. WHAT IS A FILM OUTSIDE THE AUDIENCE'S MIND?

George Stevens (1904–75)

In a sense, making movies is itself a quest. A quest for an alternative world, a world that is more satisfactory than the one we live in. That's what first appealed to me about making films. **It seemed to me a wonderful idea that you could remake the world**, hopefully a bit better, braver, and more beautiful than it was presented to us.

John Boorman (1933–)

Follow your vision.
Form secretive
Rogue Cells everywhere.
At the same time,
be not afraid of solitude.

Werner Herzog (1942–)

One day we had to write
compositions on what we wanted
to do. I wrote mine on why
I wanted to be a writer for
Mad magazine, and the boy next
to me wrote his on why he
was going to be a movie director.
And I just was, like, wait
a minute. Movie director is,
like, for big shots, people
in Hollywood. **Who told you you
could be a movie director?**
I was just so jealous and I guess
it started to dawn on me that
that was what I wanted to do.

Amy Heckerling (1954–)

I also remember being forced to sit in church, listening to a very boring sermon, but it was a very beautiful church, and I loved the music and the light streaming through the windows. **I used to sit up in the loft beside the organ, and when there were funerals, I had this marvelous long-shot view of the proceedings**, with the coffin and the black drapes, and then later at the graveyard, watching the coffin lowered into the ground. I was never frightened by these sights. I was fascinated.

Ingmar Bergman (1918–2007)

I want to risk hitting my head on the ceiling of my talent. I want to really test it out and say, "Okay, you're not that good. You just reached the level here." I don't ever want to fail, but **I want to risk failure every time out of the gate.**

Quentin Tarantino (1963–)

Cinema without risk is like having no sex and expecting to have a baby. You have to take a risk.

Francis Ford Coppola (1939–)

There is no real magic
in being a director.
**All I do is imagine in my
mind what the finished
movie will be like**,
both as a whole and the
scenes of the day.
I hear it all and I see it all.
I get this virtual mental
image of the film,
then I show up for work.

Peter Jackson (1961–)

WHEN I GO ON THE SET OF A SCENE, I INSIST ON REMAINING ALONE FOR AT LEAST TWENTY MINUTES. **I HAVE NO PRECONCEIVED IDEAS OF HOW THE SCENE SHOULD BE DONE,** BUT WAIT INSTEAD FOR THE IDEAS TO COME THAT WILL TELL ME HOW TO BEGIN.

Michelangelo Antonioni (1912–2007)

The truth is that nobody knows what that magic combination is that produces a first-rate piece of work.... **All we can do is prepare the groundwork** that allows for the "lucky accidents" that make a first-rate movie happen.

Sidney Lumet (1924–2011)

MOST OF THE GOOD THINGS IN PICTURES HAPPEN BY ACCIDENT.

John Ford (1894–1973)

Do you know what moviemaking is?
Eight hours of hard work each
day to get three minutes of film.
And during those eight hours,
there are maybe only ten or twelve
minutes, if you're lucky, of real
creation. And maybe they don't come.
Then you have to gear yourself
for another eight hours and pray
you're going to get your good
ten minutes this time. Everything
and everyone on a movie set
must be attuned to finding those
minutes of real creativity.

Ingmar Bergman (1918–2007)

PEOPLE DON'T UNDERSTAND HOW MUCH BOREDOM IS INVOLVED...WAITING FOR SOMETHING TO HAPPEN, AND THEN ALL OF A SUDDEN THE SHOT BEGINS AND YOU'RE CREATING A FANTASY. THERE'S NOTHING ELSE LIKE IT.

John Schlesinger (1926–2003)

IT'S BACK AND FORTH ALL THE WAY ALONG. YOU DEFINITELY HAVE MOMENTS OF CONFIDENCE, WHERE YOU FEEL LIKE, "WE GOT SOMETHING GREAT TODAY!" AND YOU GO HOME AT NIGHT, COMPLETELY UNABLE TO SLEEP, MAD WITH ENTHUSIASM AND CONFIDENCE. A COUPLE OF DAYS LATER, YOU'RE LOST AGAIN AND STRUGGLING TO MAKE SENSE OUT OF SOMETHING. BUT THAT'S OKAY.

Paul Thomas Anderson (1970–)

It's always a question of high aims, grandiose dreams, great bravado and confidence, and great courage at the typewriter; and then, when I'm in the midst of finishing a picture and everything's gone horribly wrong and I've reedited it and reshot it and tried to fix it, then it's merely a struggle for survival. You're happy only to be alive. **Gone are all the exalted goals and aims, all the uncompromising notions of a perfect work of art, and you're just fighting so people won't storm up the aisles with tar and feathers.**

Woody Allen (1935–)

MAKING A MOVIE WAS LIKE VOMITING. I REALLY DID NOT LOOK FORWARD TO IT, BUT AFTER I DID IT, I FELT BETTER.

Warren Beatty (1937–)

A FILM IS LIKE AN ILLNESS THAT IS EXPELLED FROM THE BODY.

Federico Fellini (1920–93)

I don't know how much movies should entertain. To me, **I'm always interested in movies that scar.** The thing I love about *Jaws* is the fact that I've never gone swimming in the ocean again.

David Fincher (1962–)

WHEN I MAKE A FILM, I DISTURB.

Jean Cocteau (1889–1963)

I MAKE MOVIES TO ENTERTAIN PEOPLE, AND **IF I'M NOT ENTERTAINED, I HAVE FAILED.** THAT'S MY MOTTO. THEY'RE SPENDING HARD-EARNED MONEY; THEY WANT TO BE TAKEN ON A RIDE.

Jerry Bruckheimer (1945–)

I just don't think about making political points. I don't have an agenda. The movies should work unto themselves. It becomes controversial sometimes, but, frankly, **I make stories. I make them exciting.**

Oliver Stone (1946–)

WITH SOME PICTURES,
PEOPLE LEAVE THE THEATER
AND IT'S FORGOTTEN.
IF PEOPLE SEE A PICTURE
OF MINE, AND THEN SIT
DOWN IN A DRUGSTORE IN
A NEIGHBORHOOD OR HAVE
COFFEE AND TALK ABOUT
IT FOR FIFTEEN MINUTES,
THAT IS A VERY FINE REWARD,
I THINK. **THAT'S GOOD
ENOUGH FOR ME.**

Billy Wilder (1906–2002)

The most painful thing is to think you will come to see the film and then forget it. It is also painful to think that you see the film, remember it for a little while, and *then* forget it. So **I try to keep you from forgetting.** I try to present a human being that you are unable to forget.

Akira Kurosawa (1910–98)

I don't believe films change anyone's mind, but I was spawned during the Roosevelt era, a time of great change, and **I still believe in trying to get people to think.**

Stanley Kramer (1913–2001)

THIS IS NOT AN ART-HOUSE
FILM. WE WANT PEOPLE
TO BE ENTERTAINED BY THE
COMEDY AND PERHAPS GET
SOME CATHARTIC PLEASURE
IN FEELING THAT THIS IS
ONE FOR OUR SIDE, THAT
THIS STICKS IT TO THE MAN.
BUT I HOPE IT'S AN AUDIENCE
THAT WILL WANT TO DO
SOMETHING WHEN IT LEAVES
THE THEATER, WHATEVER
THAT SOMETHING MIGHT BE.

Michael Moore (1954–)

I thought I was making a movie and I inadvertently made a film.

James Cameron (1954–)

I'VE ALWAYS HAD A NIGHTMARE. I DREAM THAT ONE OF MY PICTURES HAS ENDED UP IN AN ART THEATER, AND I WAKE UP SHAKING.

Walt Disney (1901–66)

WE HAVE TO GO BACK TO GUERRILLA FILMMAKING.

Spike Lee (1957–)

The Vow of Chastity
I swear to submit to the following set of rules
drawn up and confirmed by Dogme 95:

1. Shooting must be done on location.
 Props and sets must not be brought in.
2. The sound must never be produced apart
 from the image, or vice versa.
3. The camera must be handheld. Any movement or
 immobility attainable in the hand is permitted.
4. The film must be in color. Special lighting
 is not acceptable.
5. Optical work and filters are forbidden.
6. The film must not contain superficial action.
7. Temporal and geographical alienation are forbidden.
8. Genre movies are not acceptable.
9. The film format must be Academy 35 mm.
10. **The director must not be credited.**

Lars von Trier (1956–)
Thomas Vinterberg (1969–)

The artist and the multitude are natural enemies.

Robert Altman (1925–2006)

WHAT I WANT IS FOR YOU NOT TO LIKE THE FILM, TO PROTEST. I WOULD BE SORRY IF IT PLEASED YOU.

Luis Buñuel (1900–83)

THE PUBLIC IS NEVER WRONG.

Adolph Zukor (1873–1976)

The director is always right.

George Cukor (1899–1983)

I know how I feel about the film. Why do I care about reviews? Why do I care about the box office? But as soon as I ask the question, a voice in the back of my head always answers, "Because you *have* to care."

Ron Howard (1954–)

I NEVER ANSWER MY CRITICS. THAT'S THE SIGN OF A TRUE AMATEUR.

John Waters (1946–)

The one thing
I have found about
Hollywood is it's
a town full of
people who believe
in themselves,
often to a degree
where **they're
what you would
call "delusional."**

Diablo Cody (1978–)

Hollywood is the only place where you can die of encouragement.

Pauline Kael (1919–2001)

GIVEN THE CHOICE OF HOLLYWOOD OR POKING STEEL PINS IN MY EYES, I'D PREFER STEEL PINS.

Mike Leigh (1943–)

I'm not from the Mike Leigh school— I'm interested in telling a story that will reach as wide an audience as possible. The Hollywood vernacular is very useful for that; it's very much an international language.

Christopher Nolan (1970–)

I don't mind the dance that you have to do in order to get something made—the hoops you have to jump through, the fake smiles you have to adopt. You just have to. **No one is entitled to anything. You have to earn it.**

Sam Mendes (1965–)

THE WORST DEVELOPMENT
IN FILMMAKING—
PARTICULARLY IN
THE LAST FIVE YEARS—
IS HOW BADLY DIRECTORS
ARE TREATED. IT'S
BECOME ABSOLUTELY
HORRIBLE THE WAY
**THE PEOPLE WITH THE
MONEY DECIDE THEY CAN
FART IN THE KITCHEN,**
TO PUT IT BLUNTLY.

Steven Soderbergh (1963–)

LIFE IN THE MOVIE BUSINESS IS LIKE THE **BEGINNING OF A NEW LOVE AFFAIR.** IT'S FULL OF SURPRISES, AND YOU'RE CONSTANTLY GETTING FUCKED.

David Mamet* (1947–)

*From *Speed-the-Plow* (1988)

FUCK 'EM, FUCK 'EM ALL.

Robert Evans (1930–)

The problem with market-driven art making is that movies are green-lit based on past movies. So, **as nature abhors a vacuum, the system abhors originality.** Originality cannot be economically modeled.

Lana Wachowski (1965–)

THEY'RE LIKE FAST-FOOD HAMBURGERS. THEY SELL A LOT OF THEM. THE MOVIE BUSINESS IS VERY SUCCESSFUL AND YOU HOPE THAT THE SUCCESS OF THOSE HAMBURGERS WILL FINANCE MORE ORIGINAL DISHES. BUT MORE OFTEN THAN NOT, I'M AFRAID IT JUST FINANCES MORE HAMBURGERS.

Warren Beatty (1937–)

I would like to not ever
have to spend $20 million of
anybody's money on a film....
You want to make a film with
a fleet-footed and agile
crew that doesn't leave a
footprint. You don't want to
mow down things in its wake.
I like to work small and
take a gentler approach to
actually trying to capture
something. **It isn't because
I can't manage a big budget.
I just prefer not to.**

Debra Granik (1963-)

SENSITIVITY AND MONEY ARE LIKE PARALLEL LINES. THEY DON'T MEET.

Ang Lee (1954–)

THE PROBLEM IS THAT BEING
CREATIVE HAS GLAMOUR.
PEOPLE IN THE BUSINESS
END OF FILM ALWAYS SAY,
"I WANT TO BE A PRODUCER,
BUT A CREATIVE PRODUCER."
OR A WOMAN I WENT TO
SCHOOL WITH WHO SAID,
"OH YES, I MARRIED THIS
GUY. HE'S A PLUMBER
BUT HE'S VERY CREATIVE."

Woody Allen (1935–)

Now you have masses of executives who have to justify their existence and write so-called "creative notes" and have creative meetings. **They obsess about the word *creative* probably because they aren't.**

Roman Polanski (1933–)

I think one can make marvelous films that have no beginning, middle, or end.

Fred Zinnemann (1907–97)

A story should have a beginning, a middle, and an end, but **not necessarily in that order.**

Jean-Luc Godard (1930–)

No picture shall be produced which will **lower the moral standards** of those who see it.

Motion Picture Production Code of 1930 (HAYS CODE)

IT IS IN THE INTEREST OF PRODUCERS TO **MAINTAIN A CERTAIN MORAL STANDARD**, SINCE, IF THEY DON'T DO THIS, THE IMMORAL FILMS WON'T SELL.

Jean Renoir (1894–1979)

The Hays Office insisted that we couldn't show or glamorize a prostitute—that's impossible.... You know how we overcame it? We had to prominently show a sewing machine in her apartment: thus **she was not a whore, she was a "seamstress!"**

Fritz Lang (1890–1976)

NOTHING THAT IS EXPRESSED IS OBSCENE. WHAT IS OBSCENE IS WHAT IS HIDDEN.

Nagisa Oshima (1932–2013)

I don't want
to be made
pacified or made
comfortable.
I like stuff
that gets your
adrenaline going.

Kathryn Bigelow (1951–)

Quite simply, a movie has to grab me in the place that makes my voice go high and then I'll really commit to it.

Steven Spielberg (1946–)

People who look at these action movies and complain that the plots make no sense are completely missing the point, because they don't have to make sense. They're not made for people who care about plots, **they're made as an alternative to video games.**

Nora Ephron (1941–2012)

I LOVE COMEDIES, MUSICALS, AND THRILLERS LIKE EVERYBODY ELSE, BUT I CONFESS TO BELIEVING **ACTION PICTURES ARE WHAT MOVIES ARE MOST ESSENTIALLY ALL ABOUT.**

Walter Hill (1942–)

Most films reflect the world, and the world is violent and in a lot of trouble. It's not the other way around. **The films don't make a peaceful world violent—the violent world made the films.**

David Lynch (1946–)

I DON'T FEEL THE NEED TO JUSTIFY THE VIOLENCE.

IT'S WHAT EDISON INVENTED THE CAMERA FOR. IT'S SUCH A CINEMATIC THING. LITERATURE CAN'T QUITE DO IT. THEATER CAN'T QUITE DO IT. PAINTING CAN'T QUITE DO IT. CINEMA CAN DO IT. SURE, MY FILMS ARE FUCKING INTENSE. BUT IT'S A TARANTINO MOVIE. YOU DON'T GO TO A METALLICA CONCERT AND ASK THE FUCKERS TO TURN THE MUSIC DOWN.

Quentin Tarantino (1963–)

This is not the age of manners. This is the age of kicking people in the crotch and telling them something and getting a reaction. **I want to shock people into awareness.** I don't believe there's any virtue in understatement.

Kenneth Russell (1927–2011)

What you have is an
audience that is desensitized.
You have to give them
something bigger and better—
spend more money and have
something more lavish—
to even get their attention.
So, in a way, it's kind of
like you're a drug dealer,
and you've got somebody
whose habit is going up
and up, and they need a finer
and finer grade of dope.
You can't go back and give
them aspirin anymore.

John Sayles (1950–)

WHEN YOU USE VIOLENCE FOR ENTERTAINMENT, YOU'RE GETTING PRETTY LOW ON THE HUMAN SCALE.

Norman Jewison (1926–)

The point is that the violence in us, in all of us, has to be expressed constructively or **it will sink us.**

Sam Peckinpah (1925–84)

I like period pictures because when you do a period picture, if you do it right, it's sort of like a pre-shrunken shirt. It won't date, because it's already dated. It's kind of pre-dated, because you capture a moment in time.

Peter Bogdanovich (1939–)

IT'S JUST A **DAMN GOOD HOT TALE**, SO DON'T GET A LOT OF THEES, THOUS, AND THUMS IN YOUR MIND.

Cecil B. DeMille (1881–1959)

[THE STUDIO] FINALLY UNDERSTOOD THAT BLACK AND WHITE IS NOT JUST AN ARTISTIC CHOICE, IT'S AN EMOTIONAL ONE AS WELL. **THE EMOTION IS STRONGER IN BLACK AND WHITE.**

Tim Burton (1958–)

Color can do anything that black and white can.

Vincente Minnelli (1903–86)

DIGITAL, NO MATTER WHAT PEOPLE TELL YOU, IT'S BULLSHIT. THEY SAY, "OH, IT LOOKS JUST LIKE FILM." IT DOESN'T LOOK LIKE FILM AND NEVER WILL.

Michael Bay (1965–)

The cinema began with a passionate, physical relationship between celluloid and the artists and craftsmen and technicians who handled it, manipulated it, and came to know it the way a lover comes to know every inch of the body of the beloved. No matter where the cinema goes, we cannot afford to lose sight of its beginnings.

Martin Scorsese (1942–)

That celluloid, the actual film that runs through the camera, is dead. That's gone, and now digital is here. But storytelling with cinema never will die— ever, ever, ever. **The way the stories are told may change, but it will always be.**

David Lynch (1946–)

My favorite and preferred step
between imagination and image is
a strip of photochemistry that can
be held, twisted, folded, looked at
with the naked eye, or projected onto
a surface for others to see. It has
a scent, and it is imperfect. If you get
too close to the moving image, it's
like Impressionist art. And if you stand
back, it can be utterly photorealistic.
You can watch the grain, which I like
to think of as the visible, erratic
molecules of a new creative language....
Today, its years are numbered,
but **I will remain loyal to this analog
art form** until the last lab closes.

Steven Spielberg (1946–)

WE ARE PAINTING WITH LIGHT.

Rouben Mamoulian (1897–1987)

A cinematographer has to know more than just painting with light. He has to think about the movement, he has to think about what comes together when he shoots a sequence, that he knows which frames will meet. What's the rhythm of a scene, and how can he tell the story in the most visual way, the most dramatic way, to photograph a scene. **And that is much more than painting with light.**

Michael Ballhaus (1935–)

I DON'T DIRECT A FILM, I SET UP AN ATMOSPHERE AND **THE** *ATMOSPHERE* DIRECTS THE FILM.

John Cassavetes (1929–89)

My directors of photography light my films, but the colors of the sets, furnishings, clothes, hairstyles— that's me. Everything that's in front of the camera, I bring you. **I work through intuition, like a painter with a canvas, building it up.**

Pedro Almodóvar (1949–)

WHEN YOU'RE MAKING
AN ANIMATED FILM...
YOU HAVE NO CHOICE BUT
TO BUILD EVERYTHING.
IF YOU WANT A PENCIL IN
THE SCENE, OR A CUP OF
COFFEE, OR IF YOU WANT
A TREE OR GRASS, YOU HAVE
TO MAKE IT, AND SOMEBODY'S
GOING TO CHOOSE HOW IT'S
MADE. AND SO **YOU HAVE**
THE OPPORTUNITY TO DESIGN
EVERYTHING, YOU KNOW,
INCLUDING THE CLOUDS.

Wes Anderson (1969–)

IT'S JUST ATTENTION TO DETAIL. IT'S STITCH AFTER STITCH AFTER STITCH. THERE'S NO SHORTCUT.

Tony Gilroy (1956–)

Having made one film, I decided that it was the best and most beautiful form that I knew and one that I wanted to continue with. **I was in love with it, as you say, really tremendously so.**

Orson Welles (1915–85)

It's art. It's commerce. It's heartbreaking and it's fun. It's a great way to live.

Sidney Lumet (1924–2011)

I am the son
of filmmakers.
I was born with
this bow tie
made of celluloid
on my collar.

Sergio Leone (1929–89)

I want to thank Megan Carey of Princeton Architectural Press for the singular and exciting opportunity to combine my past life in the film industry with my present career of writing and book editing. Megan—editrix extraordinaire—and I share a long history. She taught me so much the first time we worked together, and I am grateful for the opportunity to learn from her again. She works exceptionally hard, but never forgets that patience and laughter (and, of course, attention to detail!) are key to the process.

Sara Bader, Russell Fernandez, and Elana Schlenker of Princeton Architectural Press were essential to the final product. They not only have the taste and discernment of true artists, but also paid attention to the minutiae of the entire concept without sacrificing content or design. What skill and balance they possess!

Thanks also to my professional mentors at Knock Knock from whom I have learned immeasurably, especially Jen Bilik, Craig Hetzer, and Erin Conley. And to Katie Arnoldi—you've always been my biggest supporter and best friend. Finally, I'd like to thank my family: my parents, Joseph and Jeri Butler, for a lifetime of encouragement; my children, Mel, Thomas, and Maddie, who inspire me (Maddie gets my special gratitude for leading me to Bookman's Alley, that labyrinthine used-book paradise in Evanston, Illinois, where I found the Bazin book that solved all my problems); and Gardner, always my unfailing champion.

Because we are human, because we are bound by gravity and the limitations of our bodies, because we live in a world where the news is often bad and the prospects disturbing, **there is a need for another world somewhere**, a world where Fred Astaire and Ginger Rogers live.

Roger Ebert (1942–2013)